W

AUTOPORTRAIT

AUTOPORTRAIT
MARTIN PARR

INTRODUCED BY MARVIN HEIFERMAN

DEWI LEWIS
PUBLISHING

IN HIS OWN IMAGE
Marvin Heiferman

In an image-clogged, fame-driven world—
where tabloids, magazines, movie screens and
television are filled to the brim and then emptied
of portraits daily—there are, no doubt, people
whose dream it is to see their image everywhere.
There are narcissists who look for themselves in
every reflective surface they pass. There are the
people who believe that whenever, and for
whatever reason, a camera points in their direc-
tion it honors and validates them. They are the
people who've learned to make love to the cam-
era by cocking their heads, moistening their lips
and looking seductively into the lens. There are

people whose professional survival depends upon whether or not they are pictured, who lean into every photo-opportunity as automatically as plants grow toward the light.

And then there's Martin Parr. A photographer attuned to the incongruities, humanity and exquisite vulgarity of popular culture, Parr literally went out of his way to star in the 57 portraits reproduced in this book. Working on photo assignments in cities as diverse as Abu Dhabi, Benidorm, and Beijing, he became intrigued by the sample portraits he saw displayed in local photo studio windows, hawked on street corners, and bolted down under plexiglas on the front of photo booths. His curiosity developed into a habit, the habit of stopping to have his portrait taken, whenever the occasion arose.

What was it that caught his sophisticated eye? A wealth of unsophisticated gimmicks: an over-sized snake in Blackpool; a Rimini beach scene irrationally crammed with silly South Seas props; the near-surreal work of an overzealous Thai retoucher; the bright blue swag curtains and equally bright fake flowers in front of a faded photo mural in Amsterdam. In what otherwise

might be interpreted as a psychologically revealing exploration for his true self, Parr seldom passed up a chance to look like someone else—an astronaut, Arab, or body builder. Intent on amassing a collection of images that would celebrate his singularity, Parr was drawn to portrait situations in which his face could appear two, five or sixteen times on a single sheet of photographic paper. He gave his manliness a shot in the arm by flinging his arm around a fake Arnold Schwarzenegger. He traveled back in time by sidling up to a man impersonating a gladiator. He manifested his soulfulness by posing demurely behind an undersized cutout of a priest in Rome's oversized Piazza Navonna.

To see his own face featured on calendars, postcards and stickers, in a seashell, on a cookie, or in a brandy snifter hovering in a starry, starry sky looks like it should have been fun. But no matter how photographers tried to transform, flatter or indulge him, Martin Parr seems to be working hard to look like Martin Parr. And in most of these pictures Parr looks less than happy. Why is the witty photographer, known for his sly pictures of bored couples, over-zealous

consumers, and misguided tourists so reluctant to crack a smile in these hilarious portraits? What photographic point is this Magnum photojournalist, off-beat fashion photographer, gallery artist and BBC filmmaker out to make? Most people are successfully trained to smile for pictures at an early age. Why is Martin Parr so intent on looking like a nineteenth century curmudgeon in these thoroughly modern pictures? Why the long face?

One hundred and sixty years ago, there was ample reason for a portrait sitter's solemnity. From the introduction of daguerreotypes through the sale of the first amateur cameras, from the 1840s through the 1880s, having a portrait taken by a photographer was a solemn event. In portrait studios in cities around the world, having a photographic likeness made was a once-in-a-lifetime, nervous-making experience. Exposures were long. Settings were artificial. Posing was uncomfortable. Strapped into neck and body braces to hold them still, responding logically to the unfamiliarity and formality of the occasion, the subjects of portraits stared off into the distance, stone faced. The goal was to create

images that would outlive the sitter and capture the essential stability of that sitter's "self".

By the twentieth century, notions of the "self," especially as it might be embodied in photographic form, did not remain stable for long. Uncountable numbers of portraits—graduation pictures, portraits of brides and of politicians, passport pictures, news pictures, movie close ups, glamour photos, portraits on drivers' licenses and the rudest paparazzi grab shots—have educated people to the highlights, pitfalls and subtleties of photographic portraiture. The success of new mass media that profited from the delivery, consumption and disposal of changing images, convincingly suggested that it was normal to expect to be photographed frequently and in varying guises and circumstances. And to that end the public could study the growing archive of photographic images, to observe and absorb their finer points and use that information to build up their own repertoires of attitudes and gestures that would help lessen self-consciousness when cameras pointed their way.

With hands on experience on both sides of the camera, we've all become photographers

and models. We've come to understand that portrait sessions need not be rule bound and may not be documentary events at all. In the past, portraits may have been a reflection of the pressure to conform to social norms and the conventions of age, gender, race, physical beauty, occupation, social and civic status, and class. But not now, not in a world where visual fantasies are available to consumers every time they walk down the street. Portraits have become collaborative, constructed, and increasingly democratic, the detailed representations of a photographically obsessed culture's wishful thinking. They show us pictures of ourselves not necessarily as we are, but as we'd like to be seen.

If posing for portraits still triggers nervousness, it's a different kind of discomfort than nineteenth century sitters experienced, now that photography isn't the medium of mystery it once was. Perhaps we've become less fearful about what a picture might reveal about us, but more anxious about what level of control we are capable of exerting over our own image. Despite that anxiety, we're still willing to perform when the photographer depresses his or her shutter. And

why not? Most photographs will end up in envelopes, albums, boxes, and drawers, out of sight. And others will be torn up and thrown away like trash. And there will be many more chances to get it right in the future.

The nostalgic belief that any photographic portrait can literally or figuratively capture the soul of its subject is long, long gone. Decades ago, the late Garry Winogrand explained his obsession with photography by saying that what interested him most about being a photographer was the chance to see what things looked like photographed. Ultimately, for Winogrand, it was the final image itself that was important, not the subject of the image. Back then, that kind of a statement made sense only to photographers. Today it's become an everyday cultural truth. We are fascinated by, and are critical of, what things look like when they are photographed, especially when those things are ourselves.

So perhaps it's not an old-fashioned seriousness that we're seeing in Martin Parr's face. When Parr the photographer becomes Parr the subject, he's got good reason not to laugh.

Parr's generally dour, blank or bland expressions as he stares into other photographers' cameras are not intended to make him look high-minded, pensive, or strong. Besides reminding us of Parr's refined ironic edge, his determined, Mona-Lisa like demeanor is the tool that best allows him to predict and control what the final images will look like.

Who better than Parr, a photographer whose own work tracks the irreversible homogenization of world culture, to pose as Everyman in order to assemble this series of portraits of a seemingly homogenized self. As different as they are, one from the next, these portraits reveal more about photography and contemporary culture than they do about Martin Parr. By keeping a straight face under the silliest of circumstances, he's spotlighting the artifice of each of these portraits to give us a better sense of how and why these pictures taken by other photographers work to hold our interest. These "autoportraits" are reminders of how completely and poignantly our self-definition is tied in with our demand for photographic excitement in an impatient consumer culture ever on the watch for novelty, romance,

exoticism, and picture perfect moments. Strip away the names of their city of origin, and each of these portraits is another goofy but stunning reminder of how invaluable the malleable medium of photography has become in affirming our ever-malleable, ever-ambivalent selves.

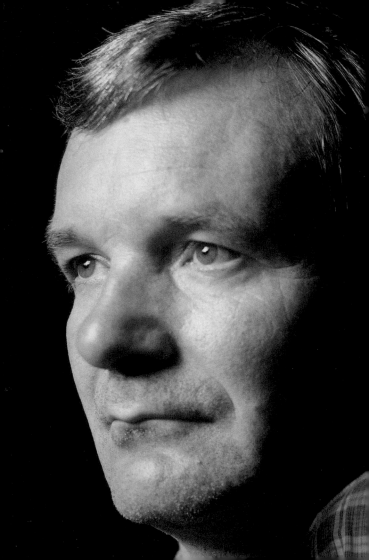

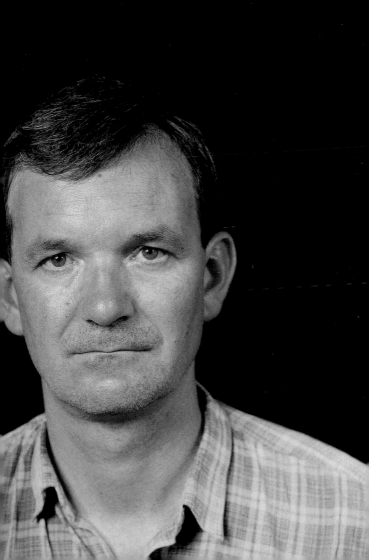

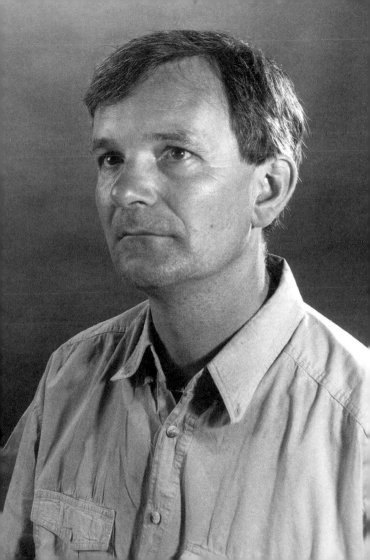

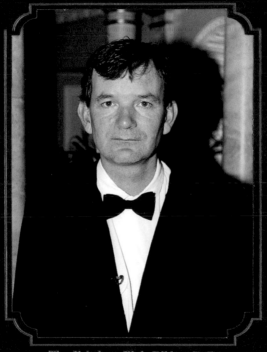

The Fabulous Pink Ribbon Ball
The Dorchester

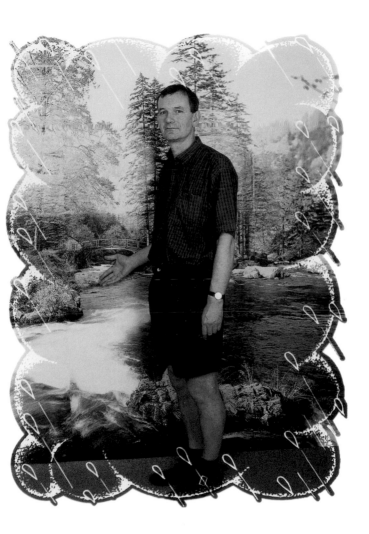

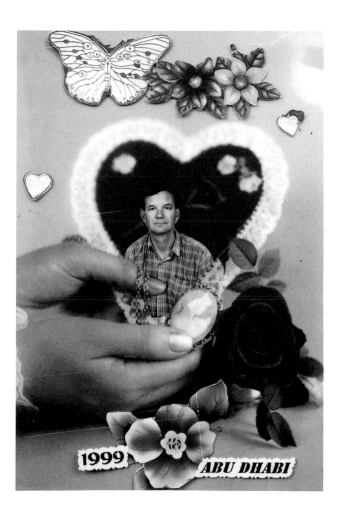

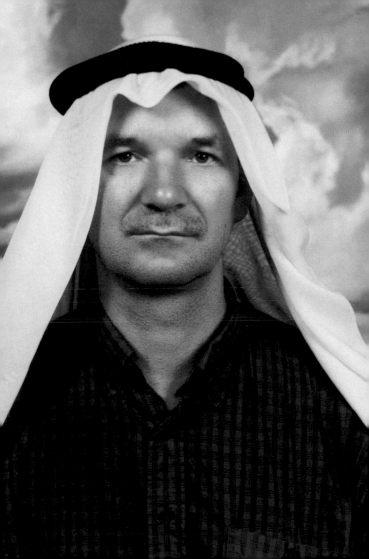

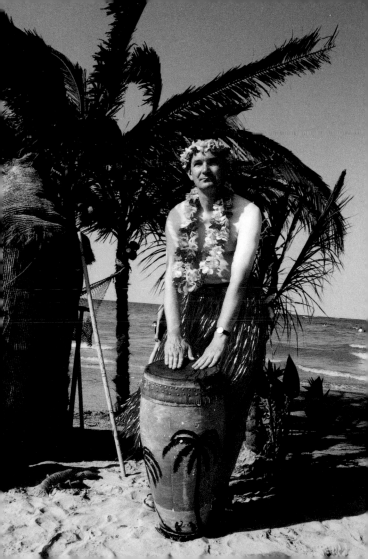

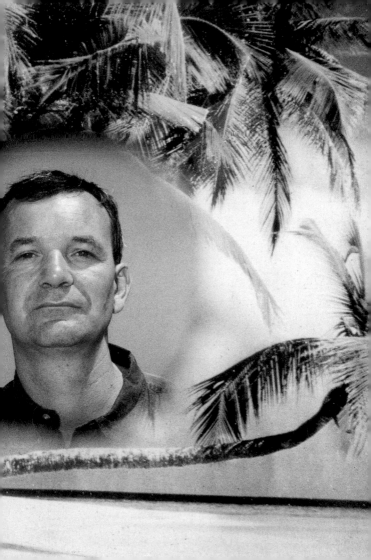

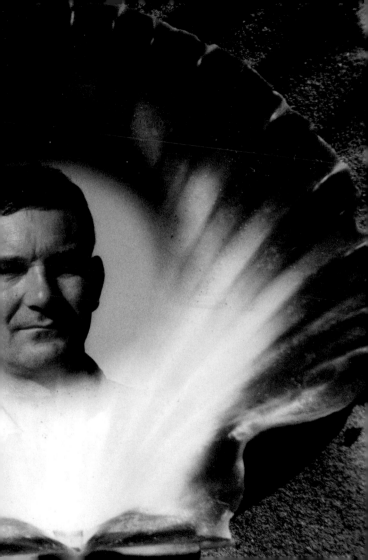

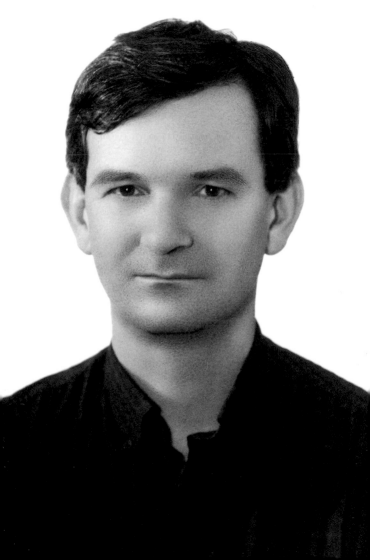

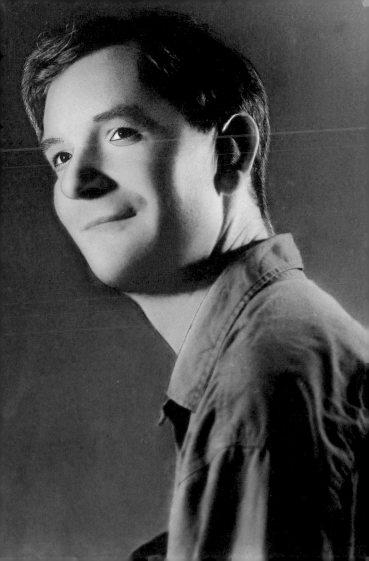

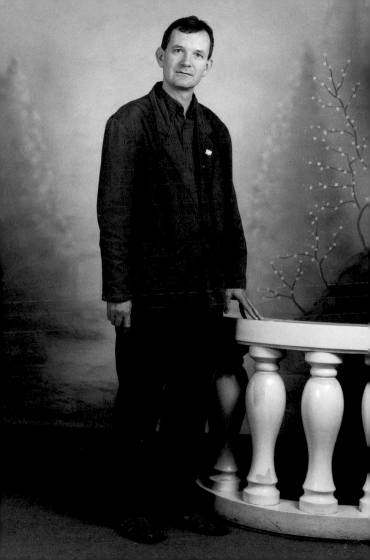

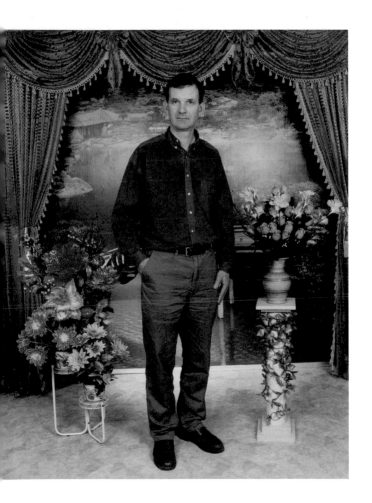

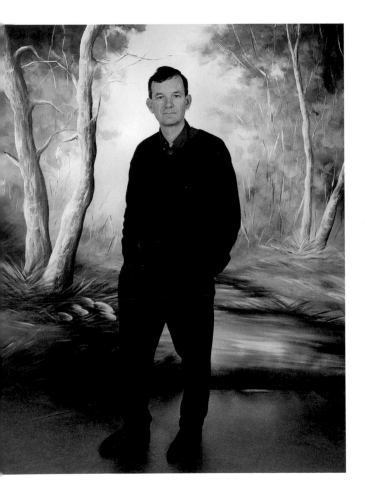

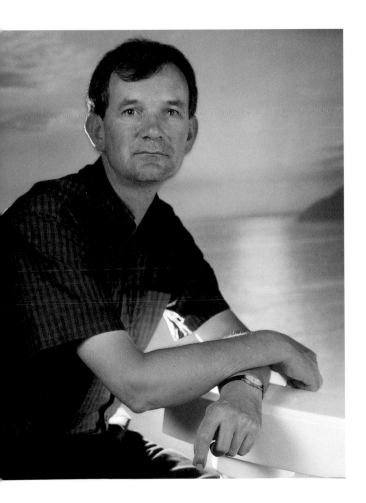

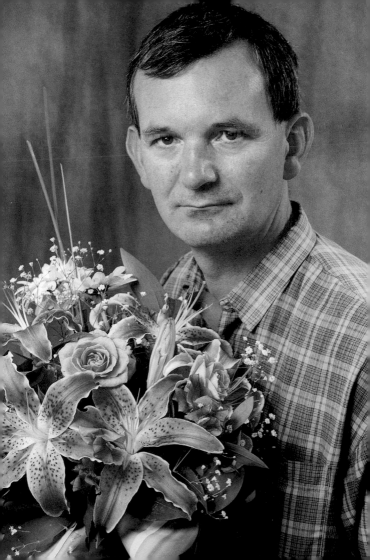

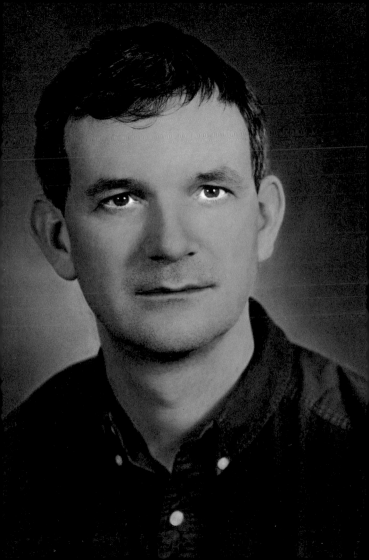

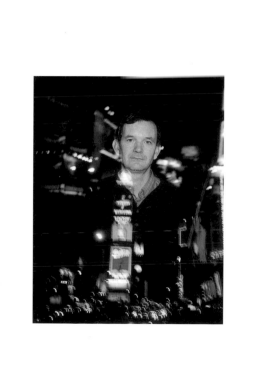

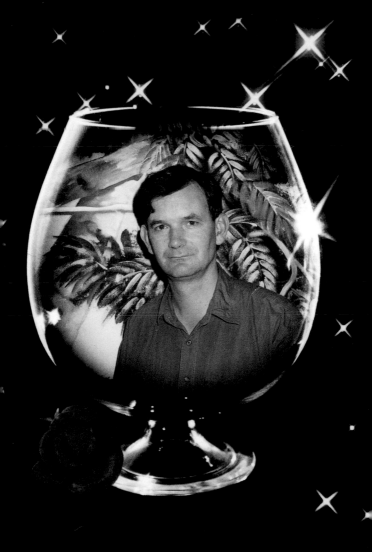

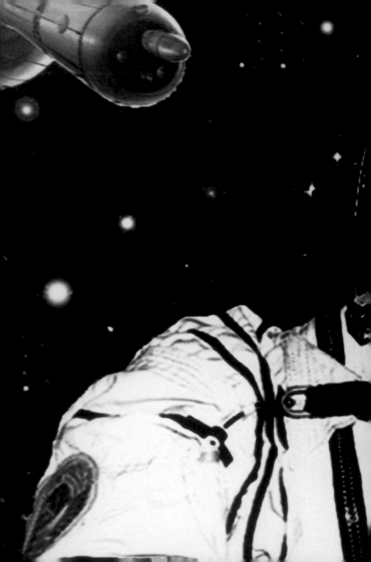

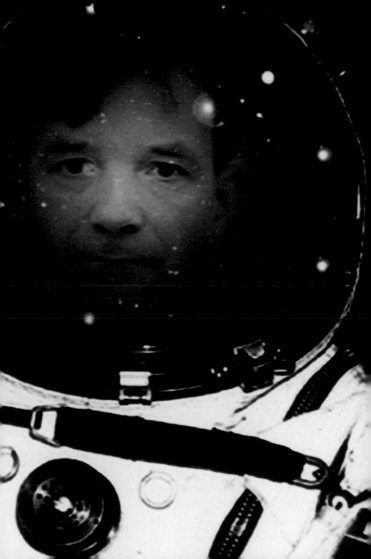

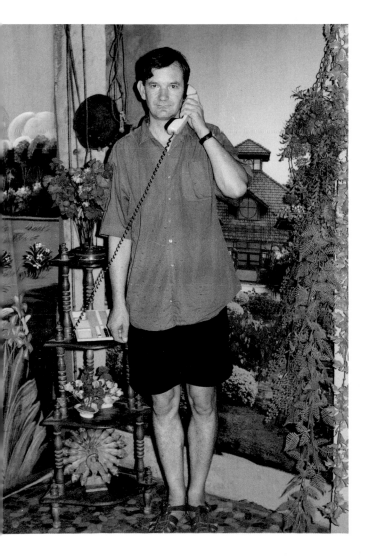

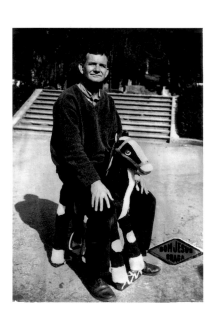

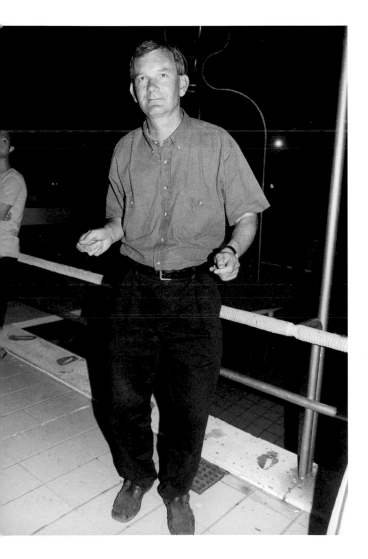

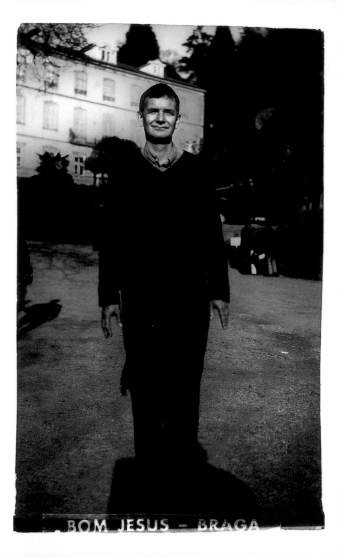

BOM JESUS – BRAGA

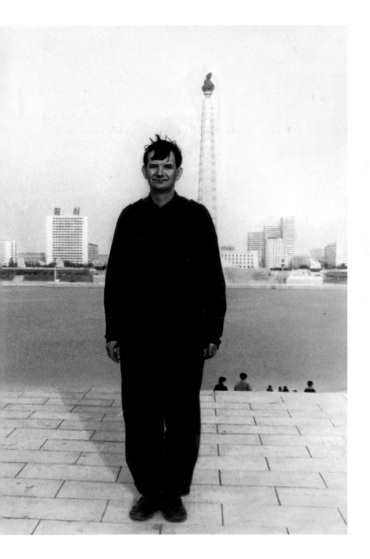

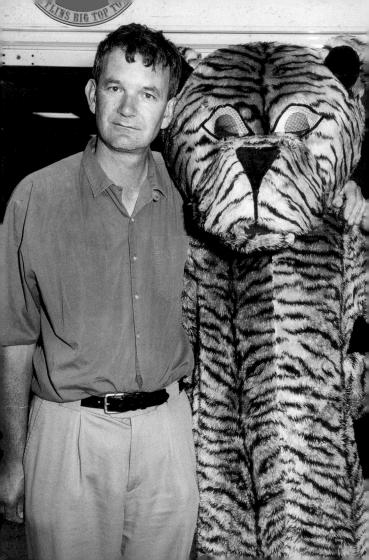

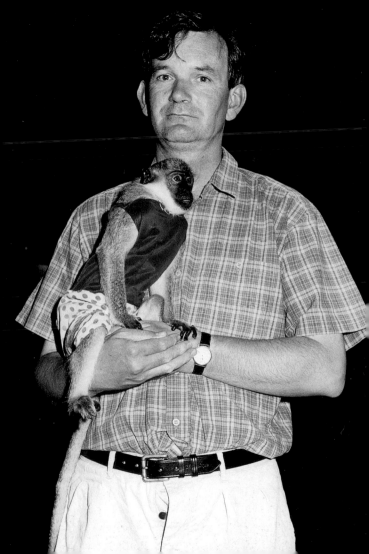

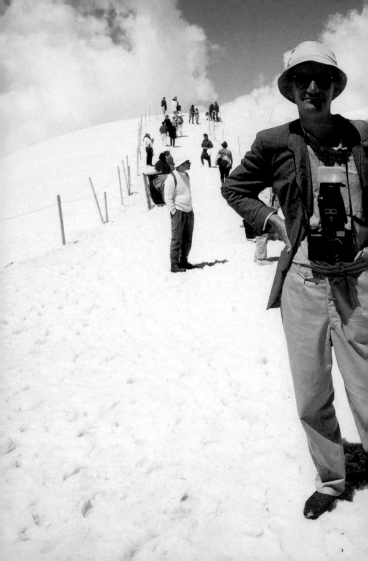

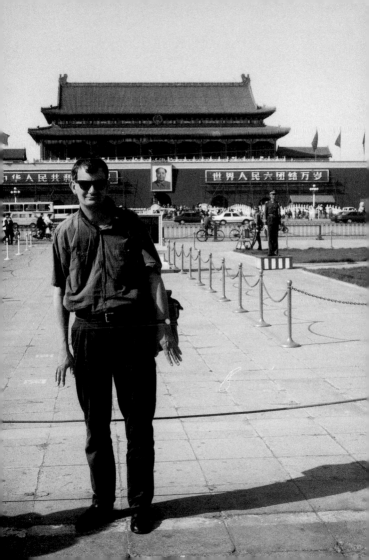

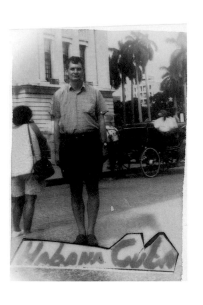

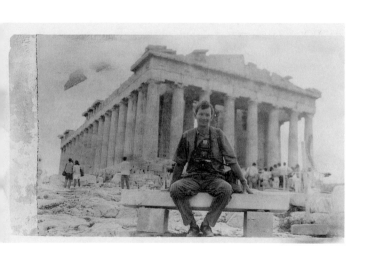

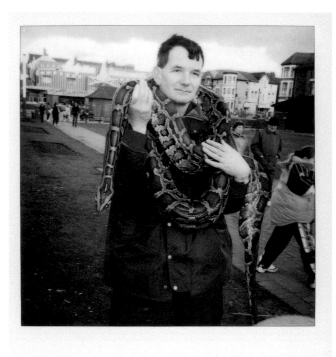

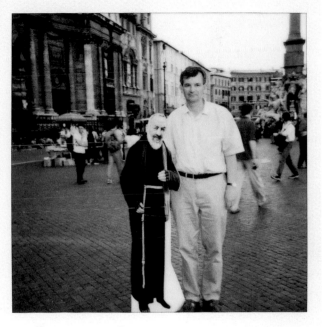

Padre Pio 1·5·99 Rome

スージー パー先生

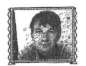

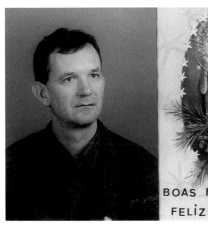

BOAS FESTAS

FELIZ ANO NOVO

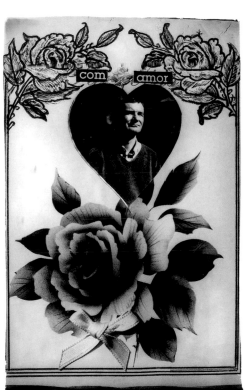

com amor

BOM JESUS - BRAGA

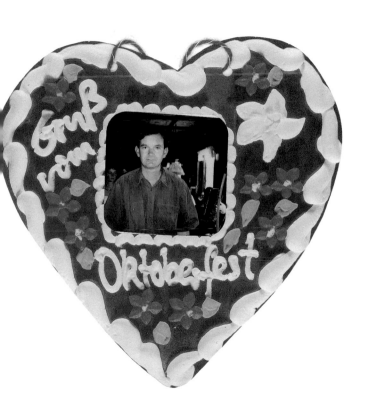

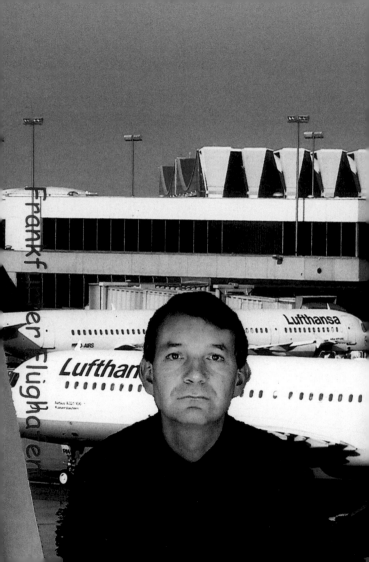

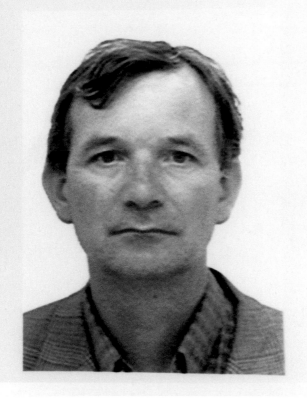

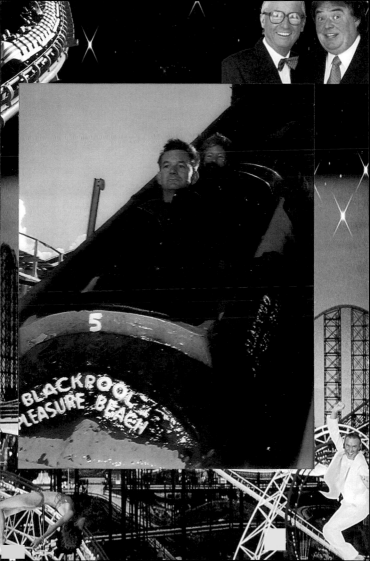

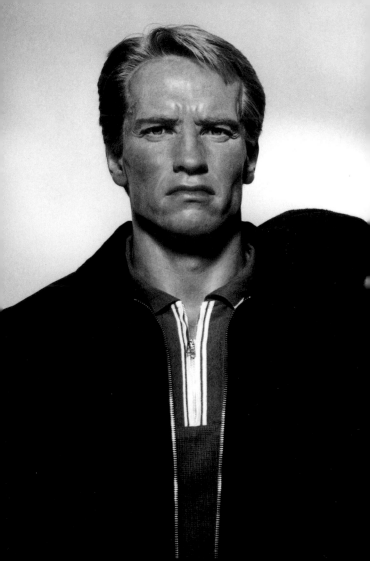

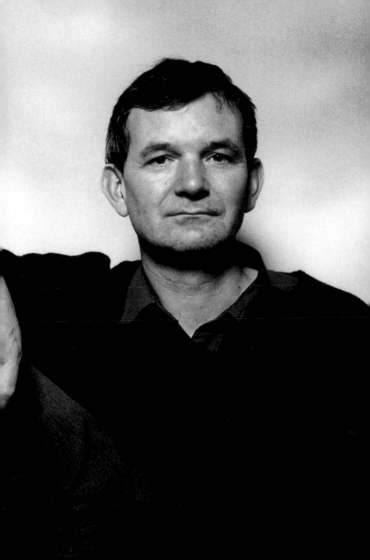

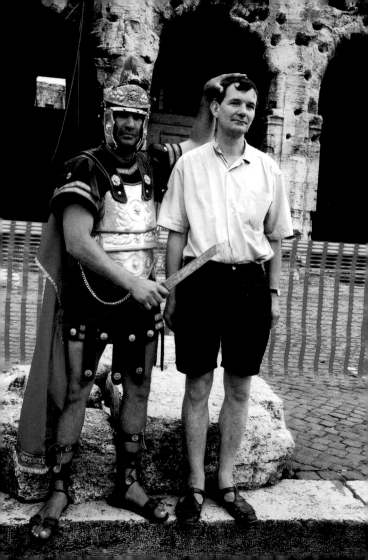

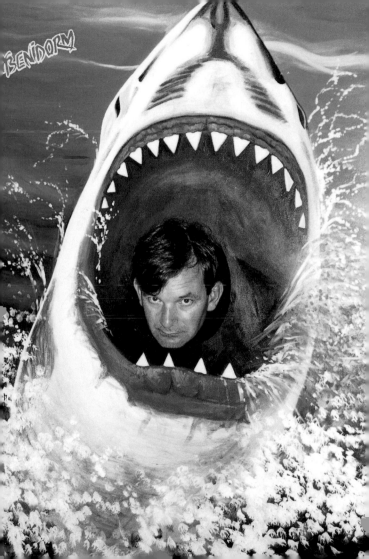

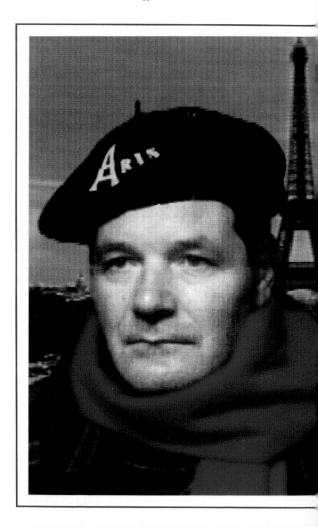

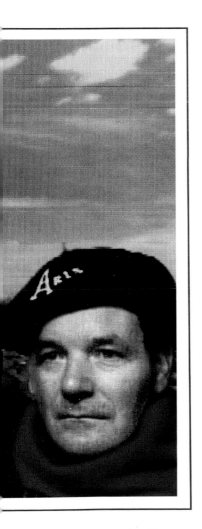

2ᵉ
étage

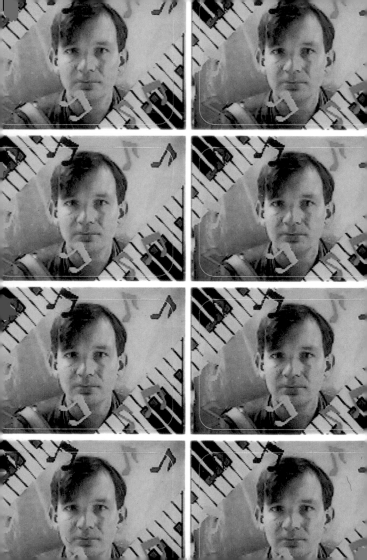

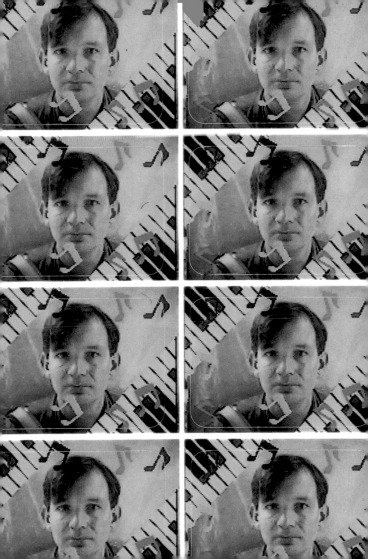

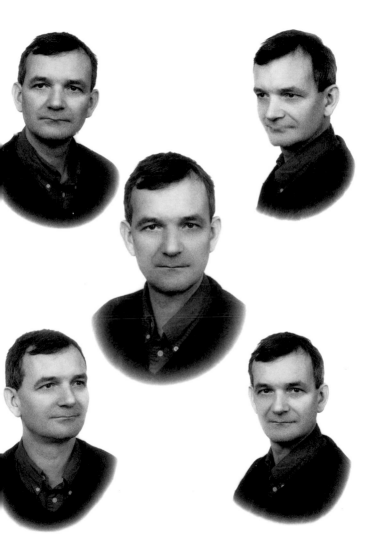

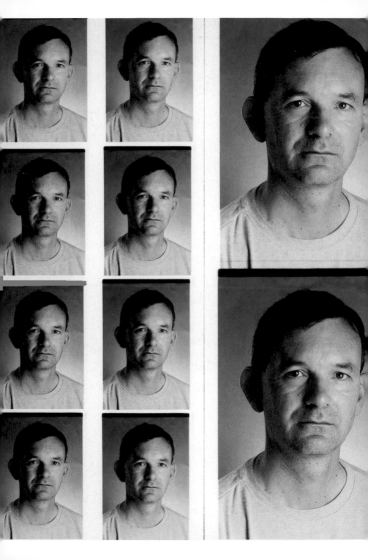

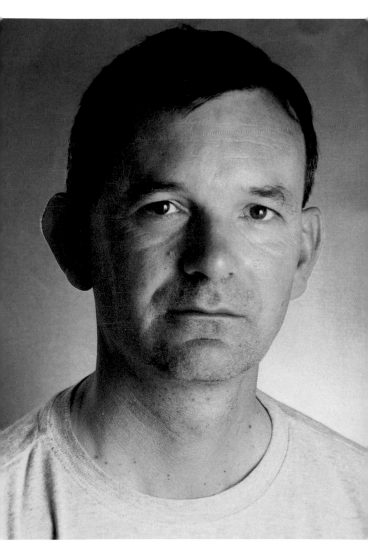

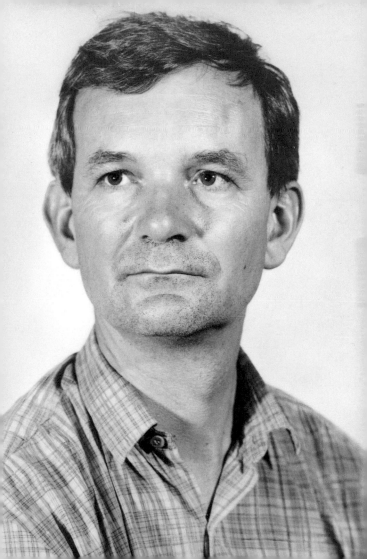

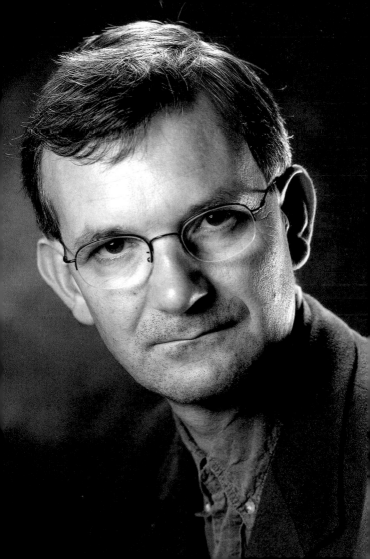

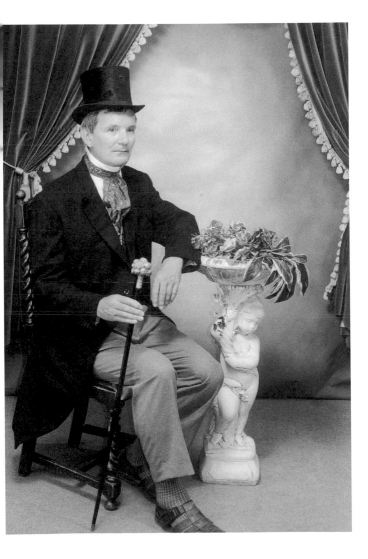

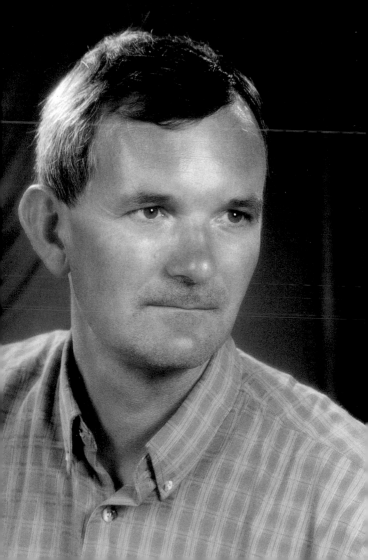

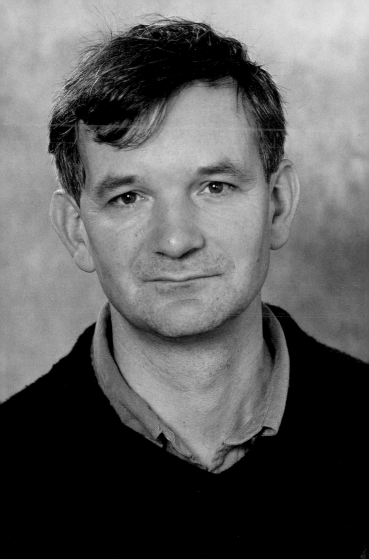

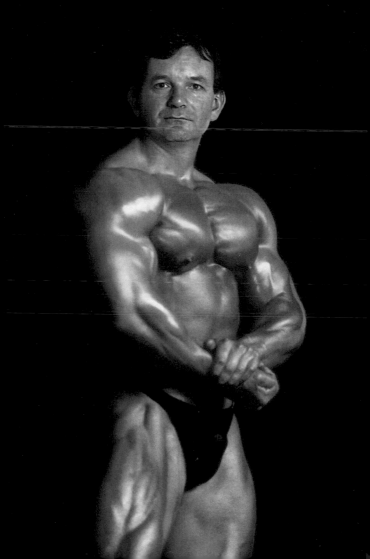

Locations

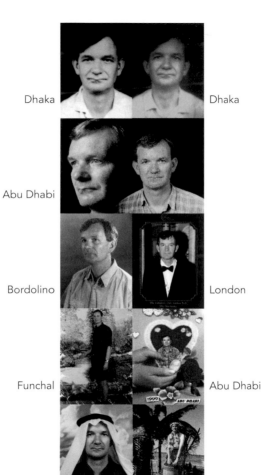

Dhaka

Dhaka

Abu Dhabi

Bordolino

London

Funchal

Abu Dhabi

Abu Dhabi

Rimini

Rimini

Rimini

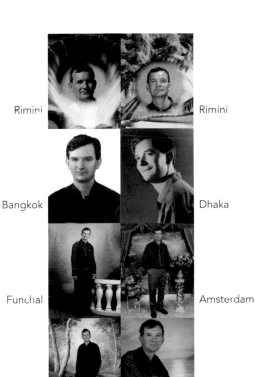

Bangkok

Dhaka

Funchal

Amsterdam

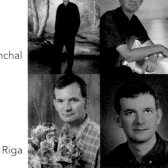

Funchal

Benidorm

Riga

Amsterdam

New York

Jamaica

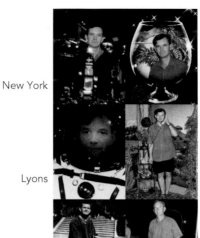

Lyons

Dhaka

Braga

Rimini

Braga

Pyongong

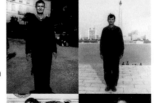

Minehead

Benidorm

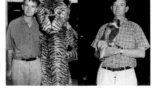

Jungfrau

Beijing

Havana

Athens

Blackpool

Rome

Tokyo

Funchal

Braga

Munich

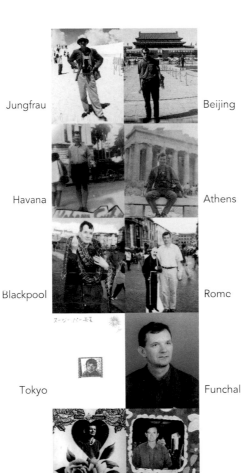

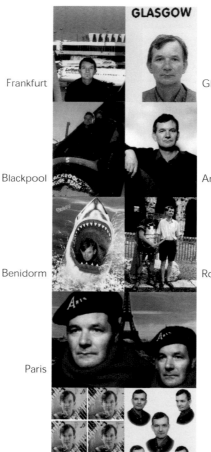

GLASGOW

Frankfurt

Glasgow

Blackpool

Amsterdam

Benidorm

Rome

Paris

Tokyo

Braga

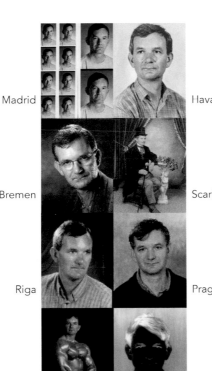

Madrid

Havana

Bremen

Scarborough

Riga

Prague

New York

Dhaka

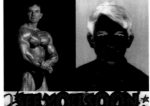

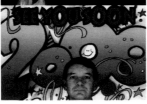

Frankfurt

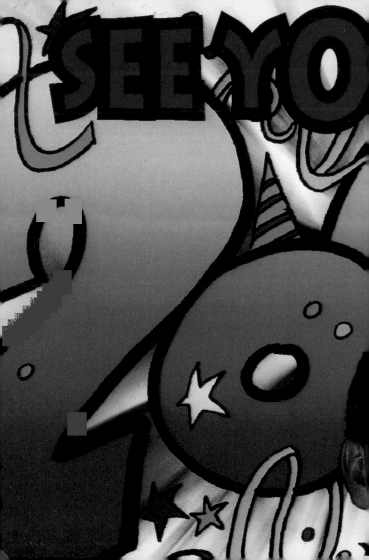

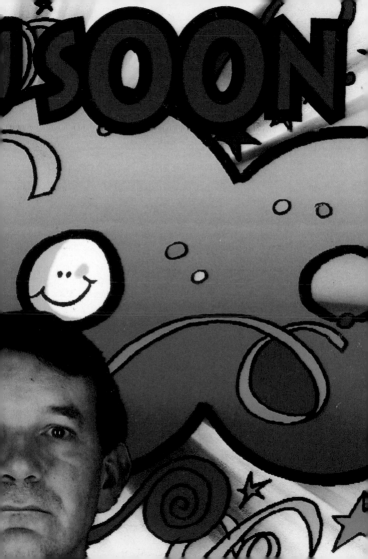

First published in the United Kingdom in 2000 by
Dewi Lewis Publishing, 8 Broomfield Road,
Heaton Moor, Stockport SK4 4ND, England
+44 (0)161 442 9450

From the collection of Martin Parr.
The publisher acknowledges and thanks all the
photographers and studios who have granted permission
for publication. All reasonable efforts have been made
to trace copyright holders and we apologise to any
that we have not been able to reach.

ISBN: 1-899235-72-8

Designed and edited by Dewi Lewis
Printed in Italy by EBS, Verona

3 5 7 9 8 6 4 2

First Edition